Copyright
(c)

Introduction

The pages within this Game Of Thrones Illustrated art poster book feature many of the best known characters from the hit television series. Each figure has been carefully recreated to look as life-like as possible, and each one would look great either used as a poster or framed. Or, you could simply keep the book as it is to add to your collection of Game Of Thrones memorabilia.

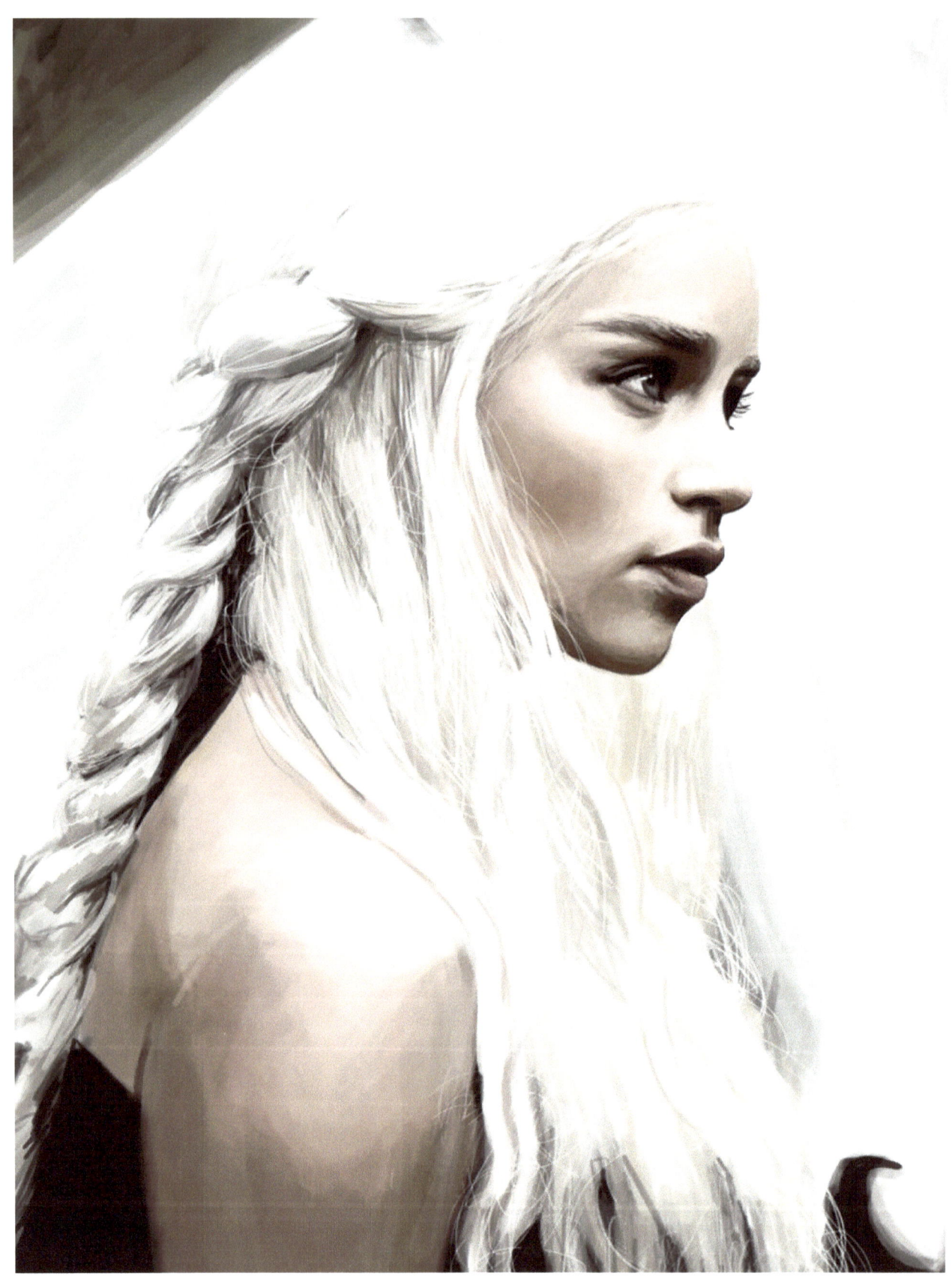

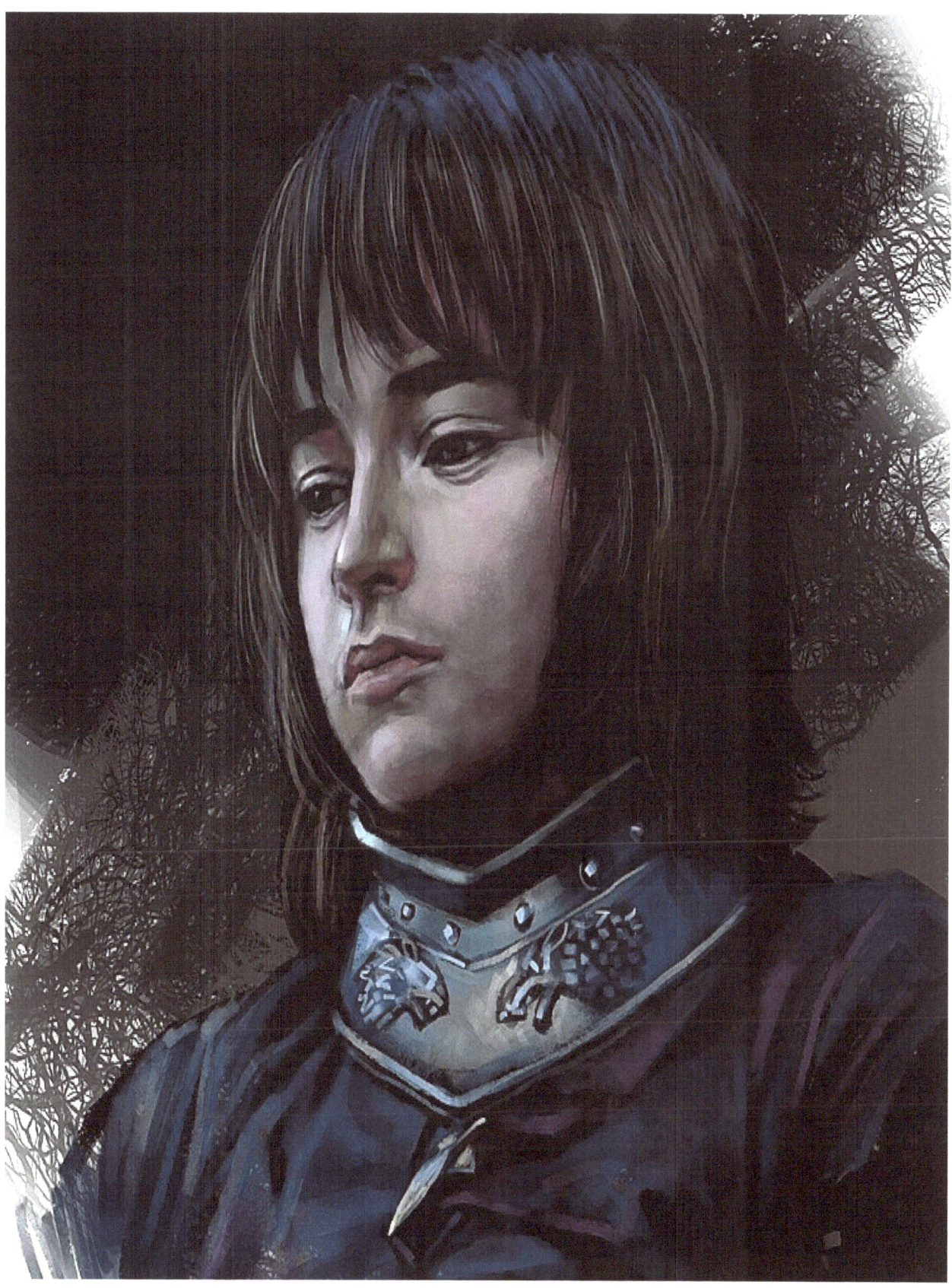

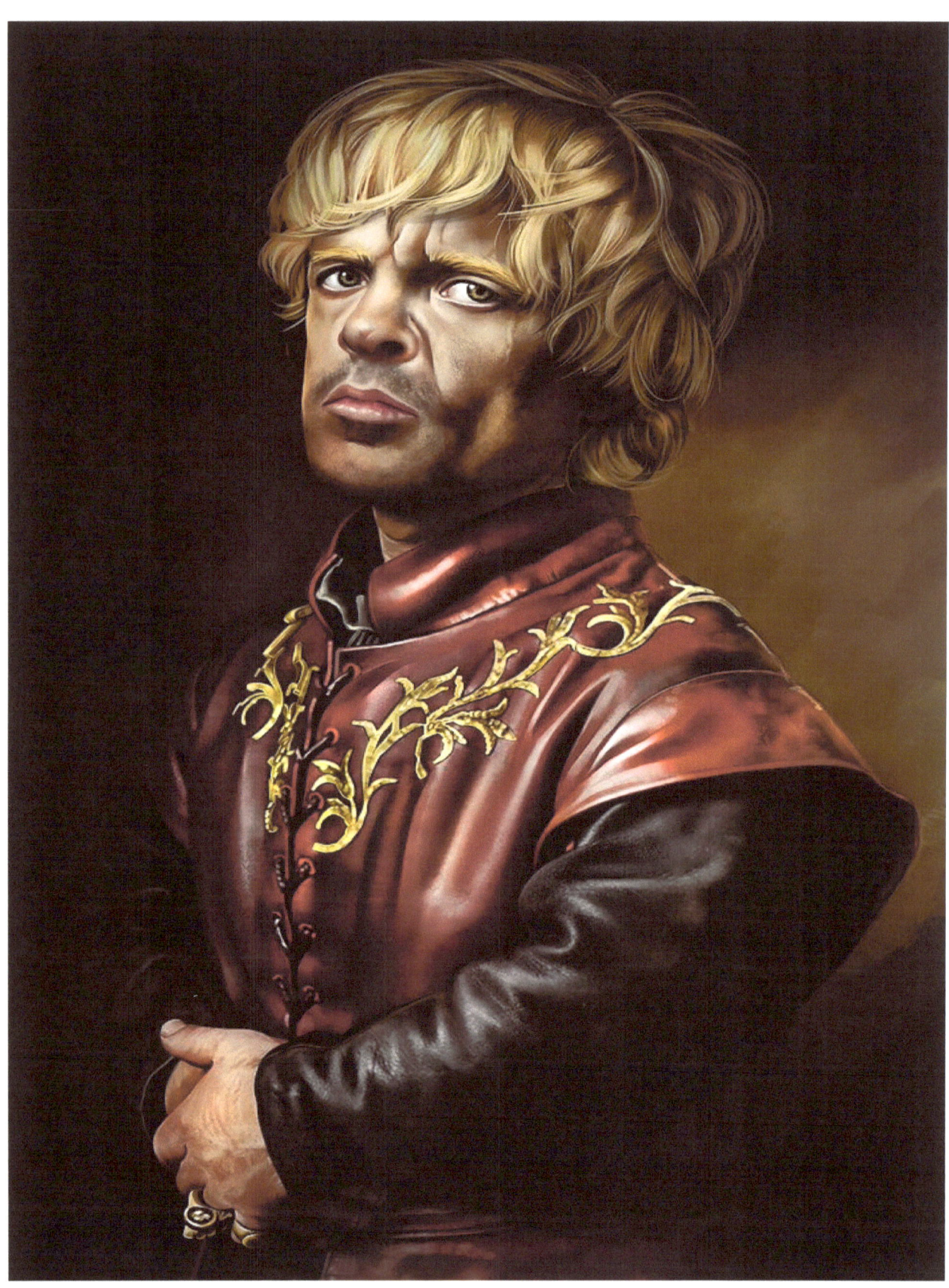

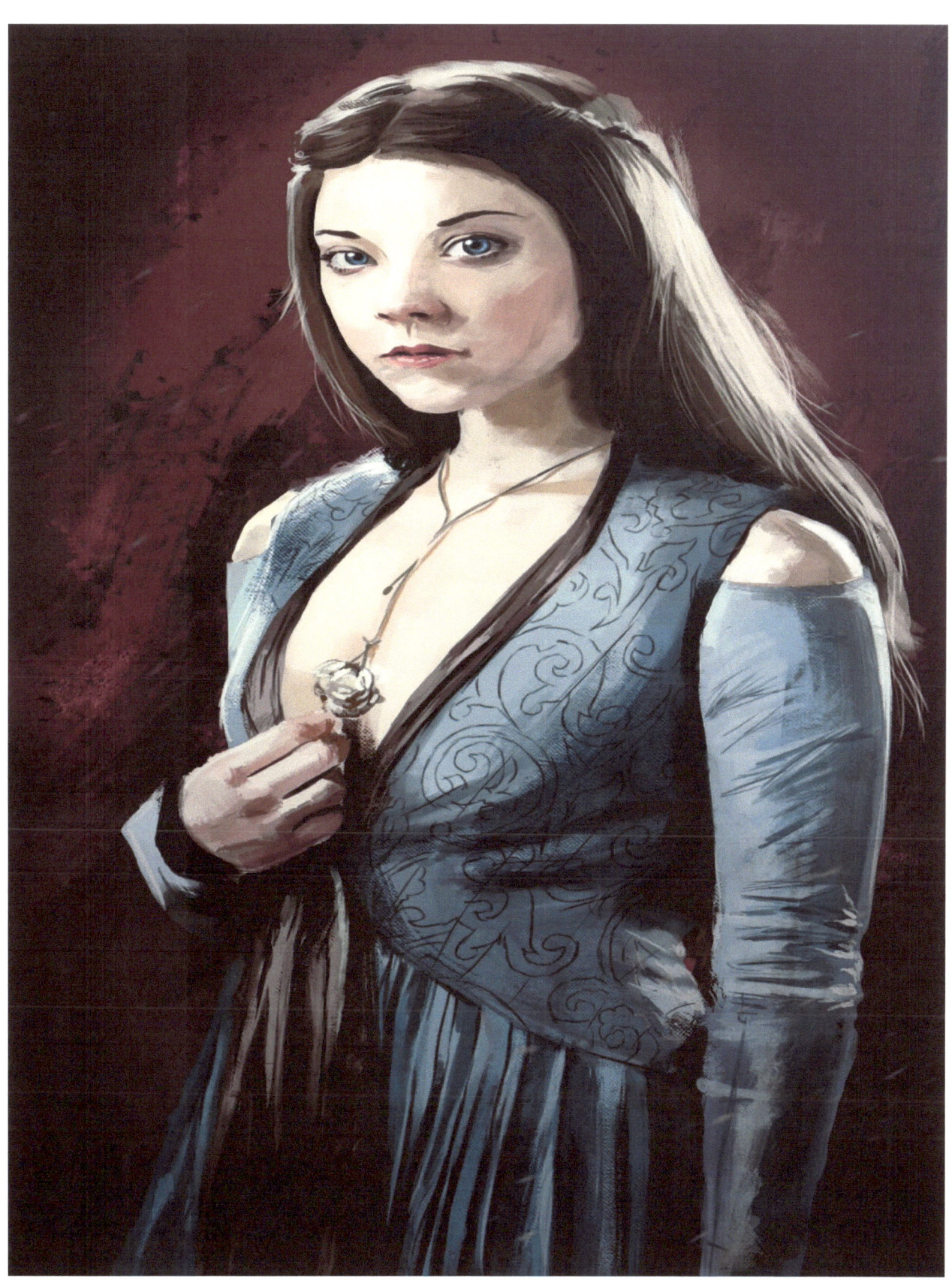

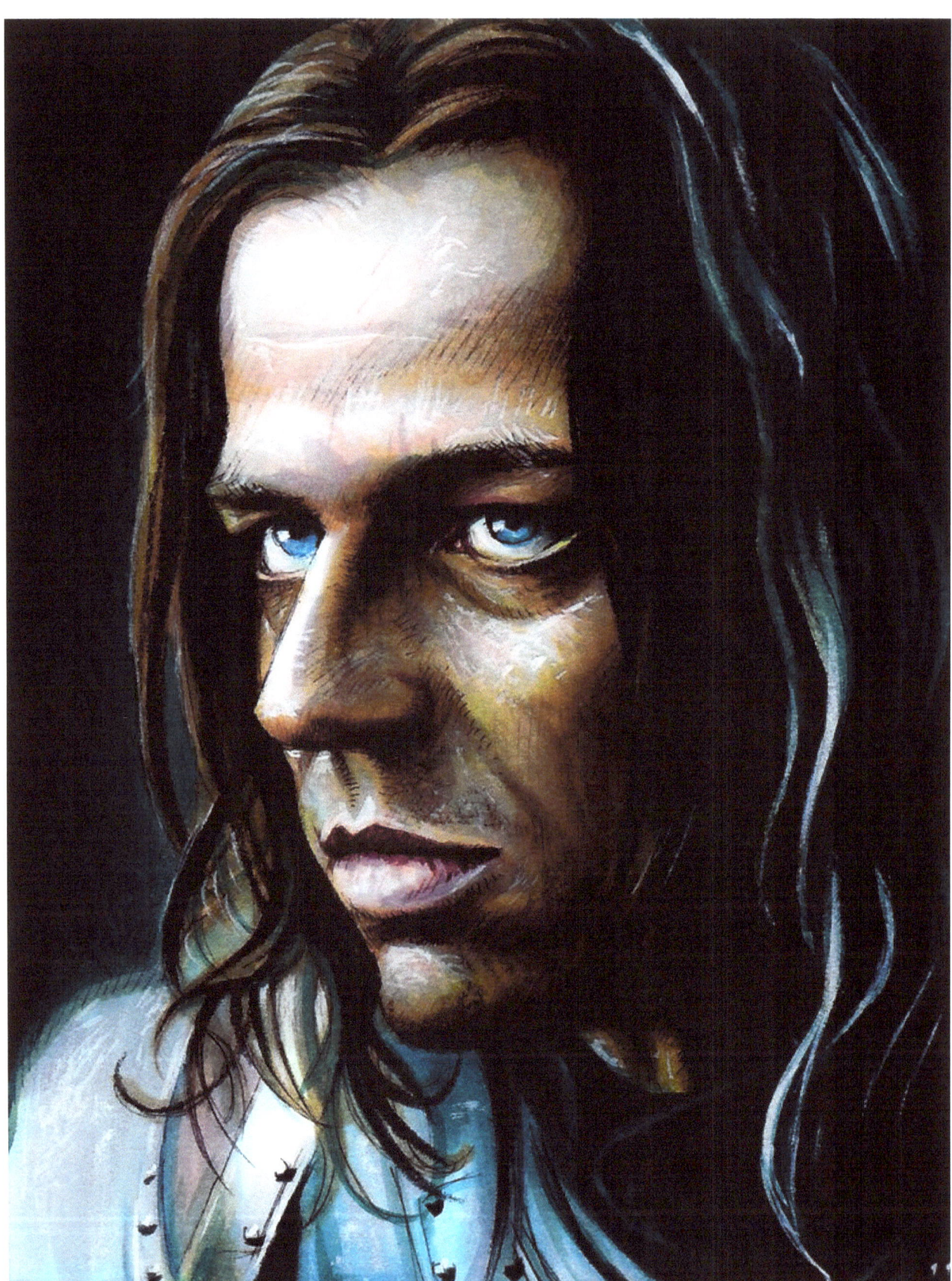

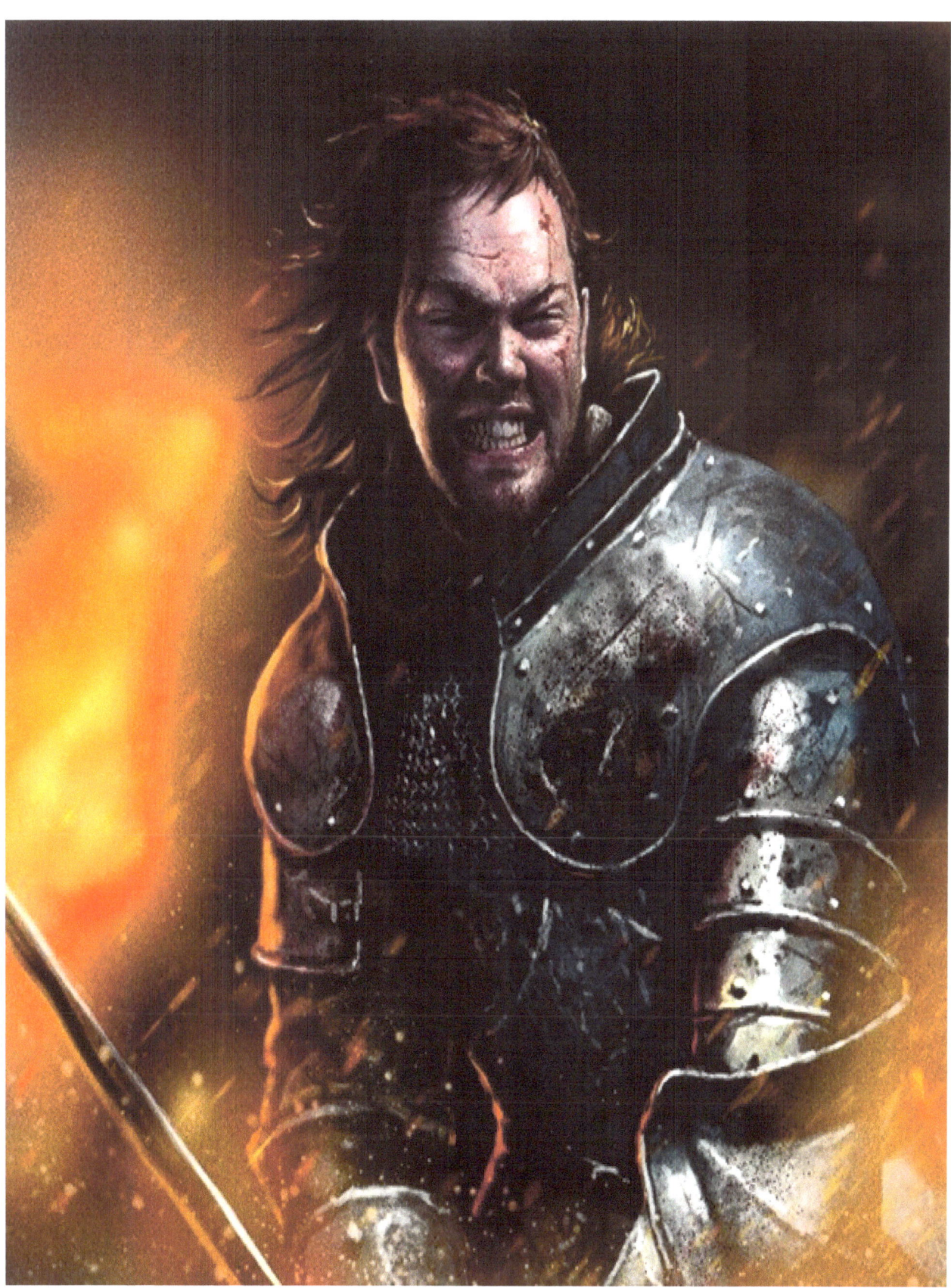

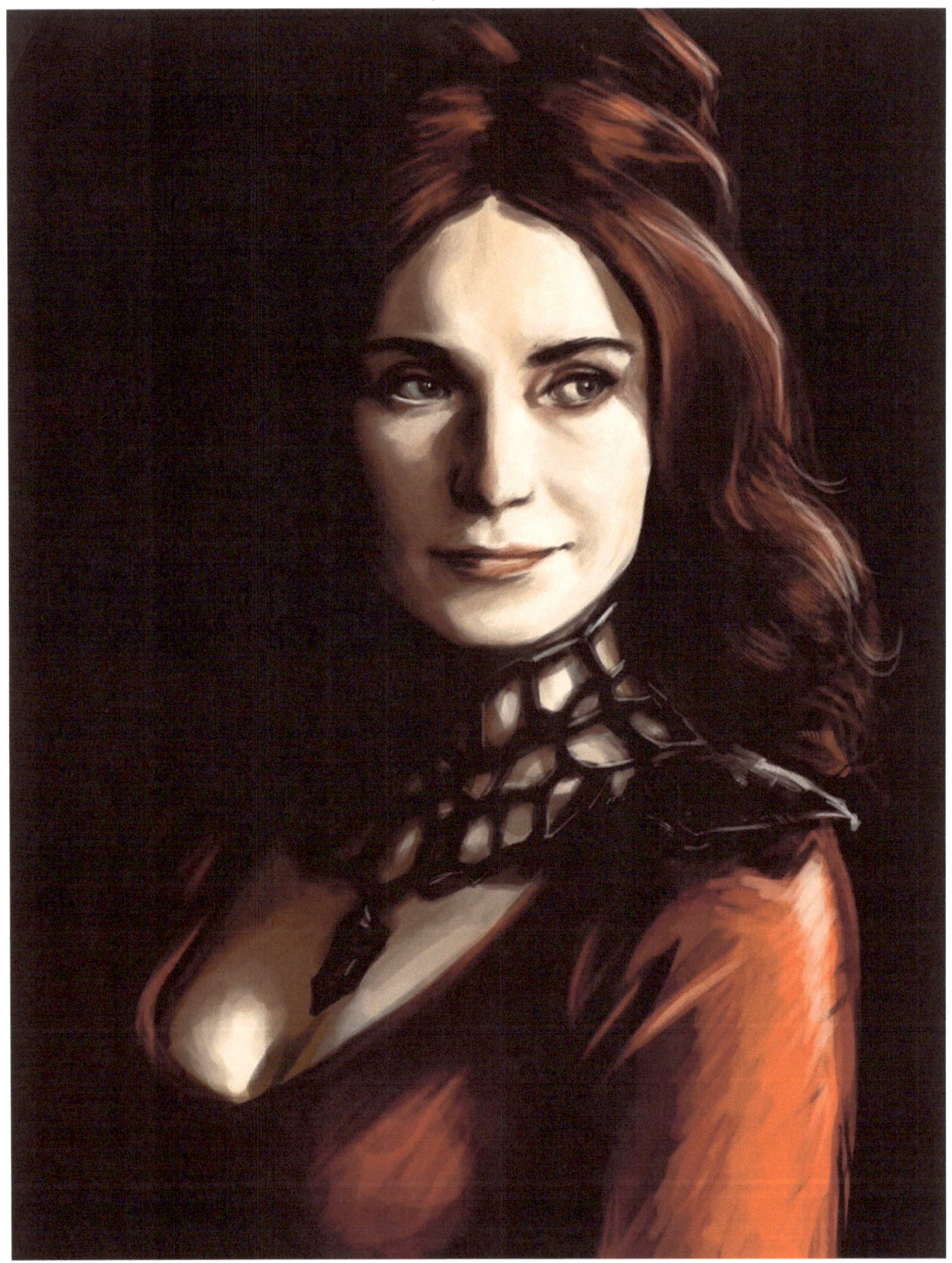

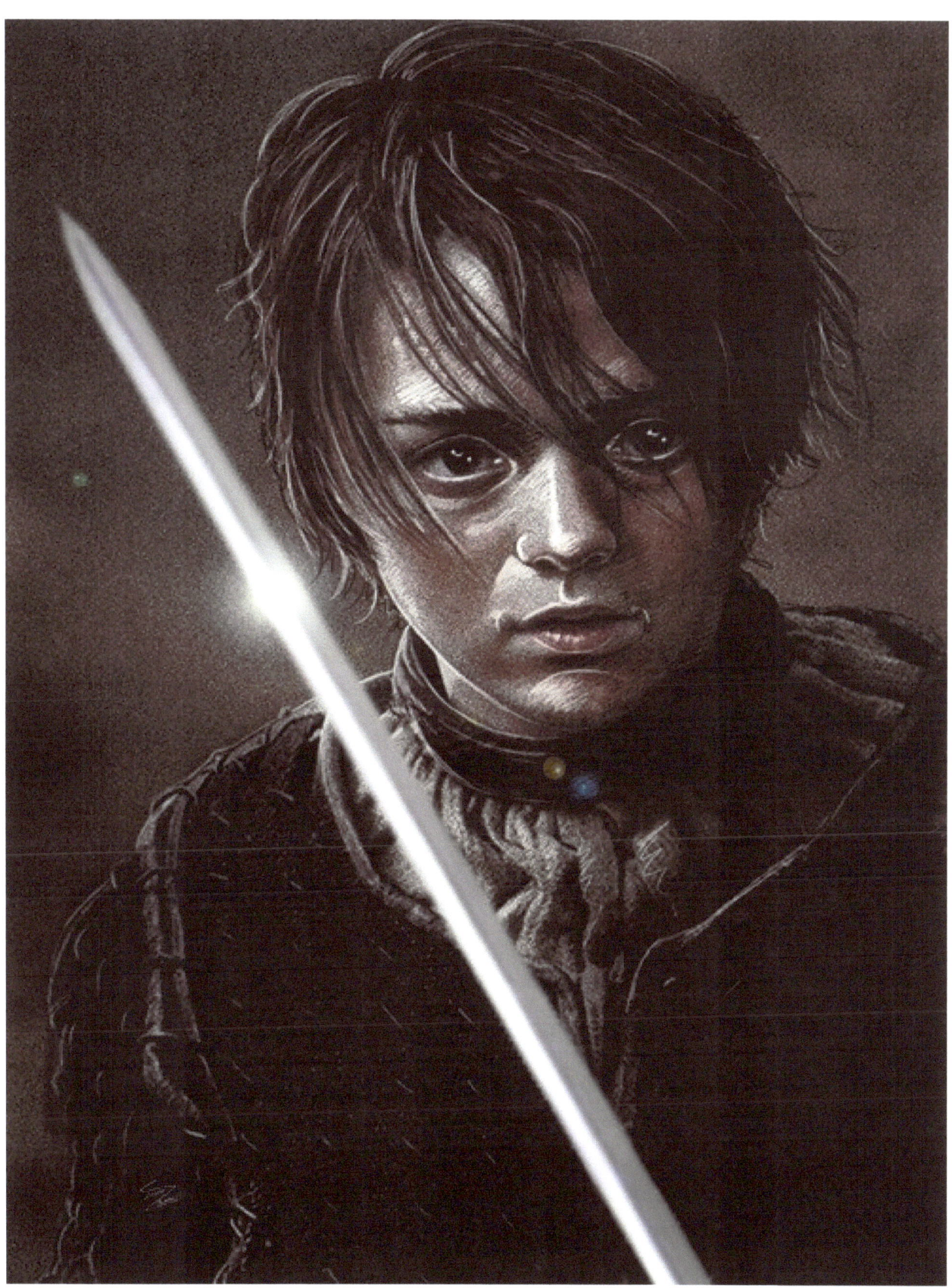

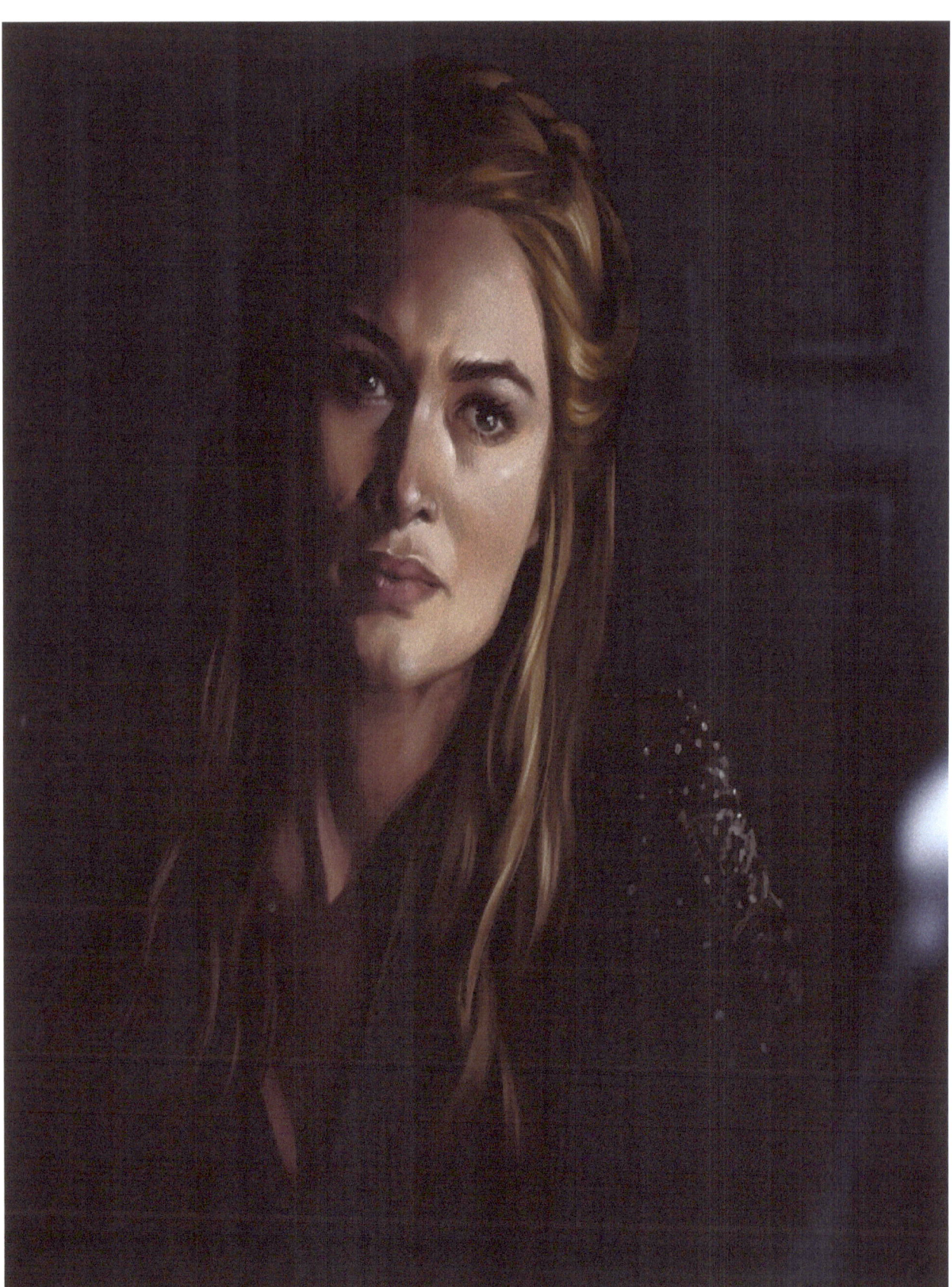

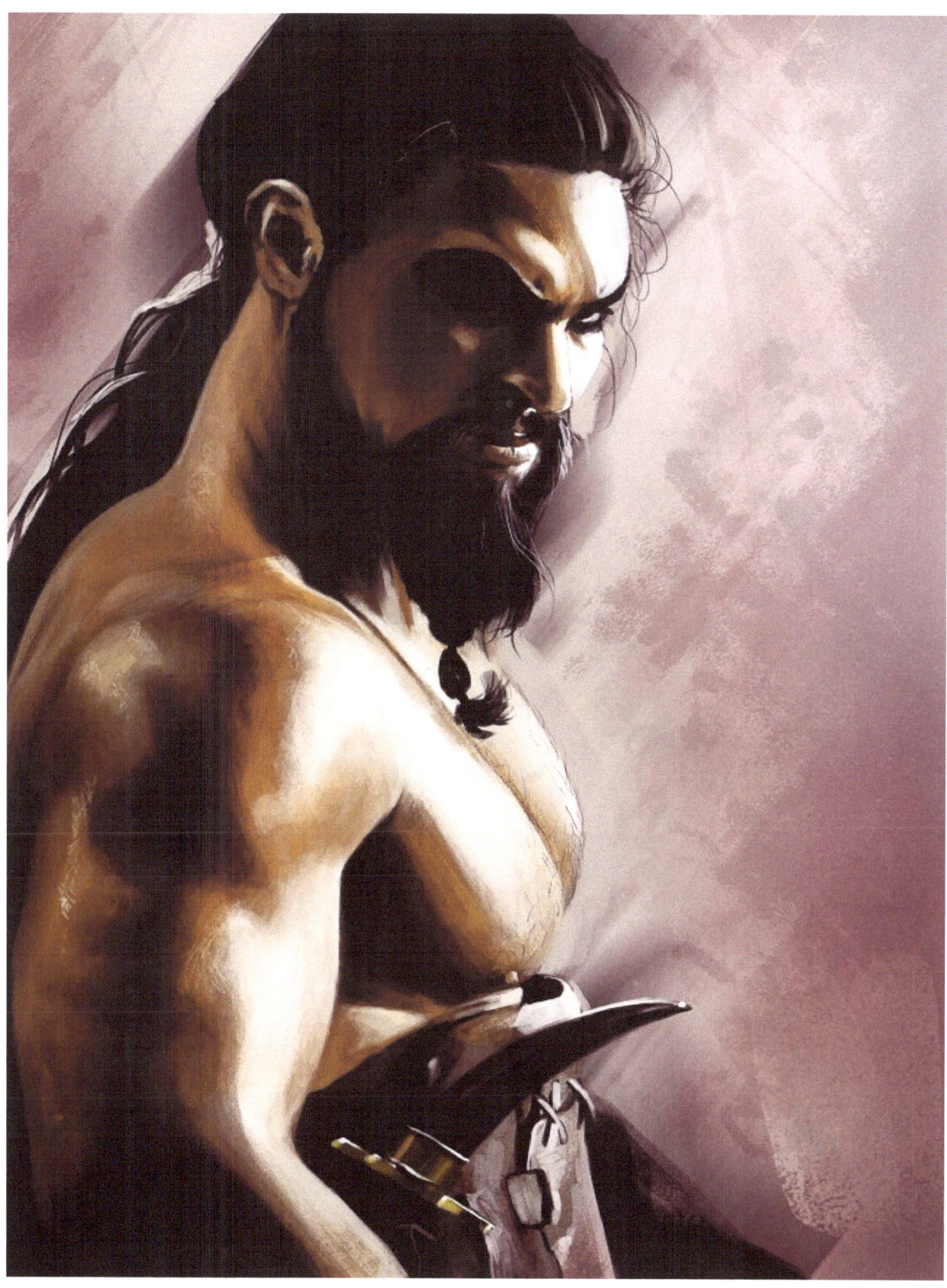

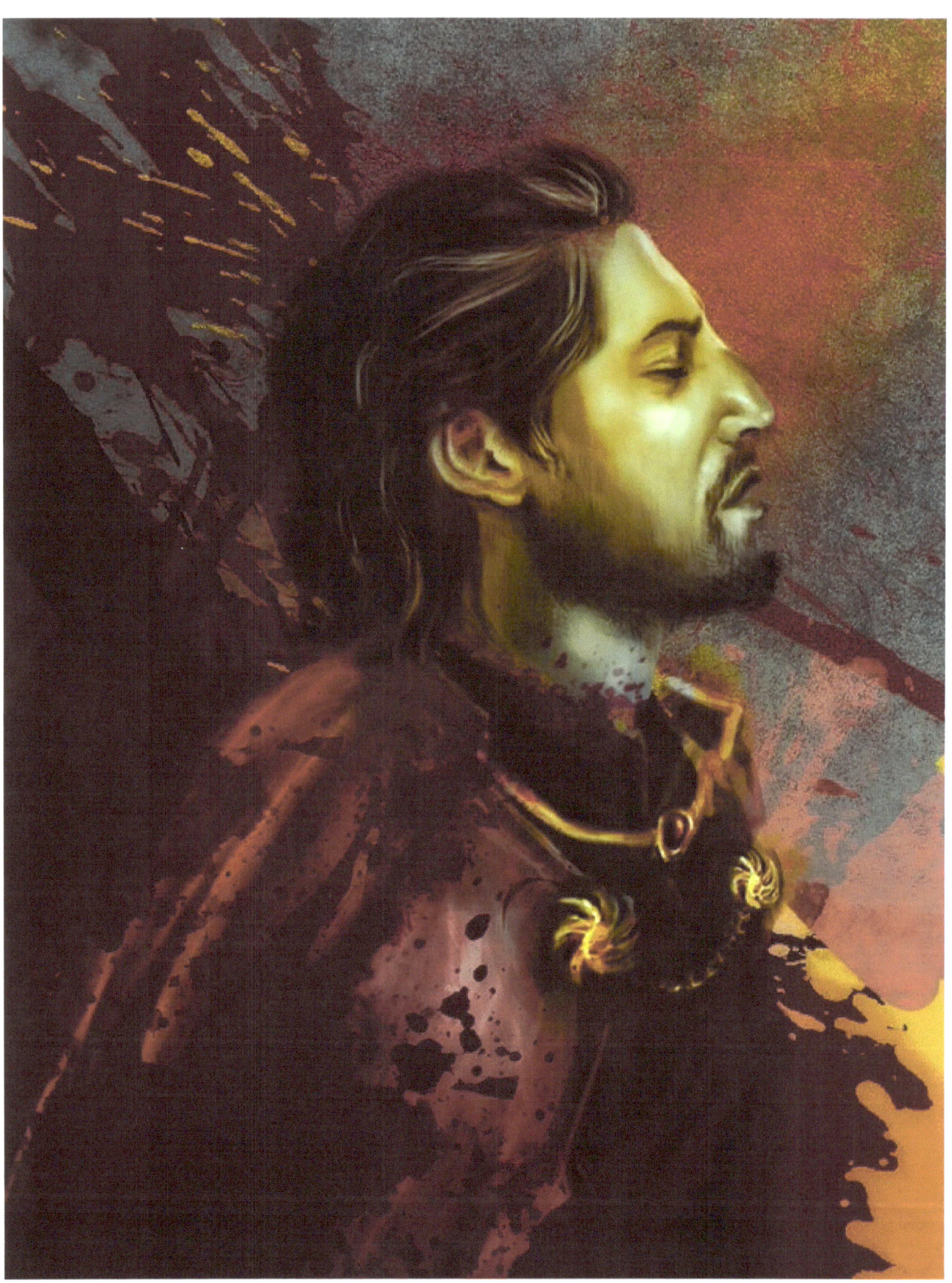

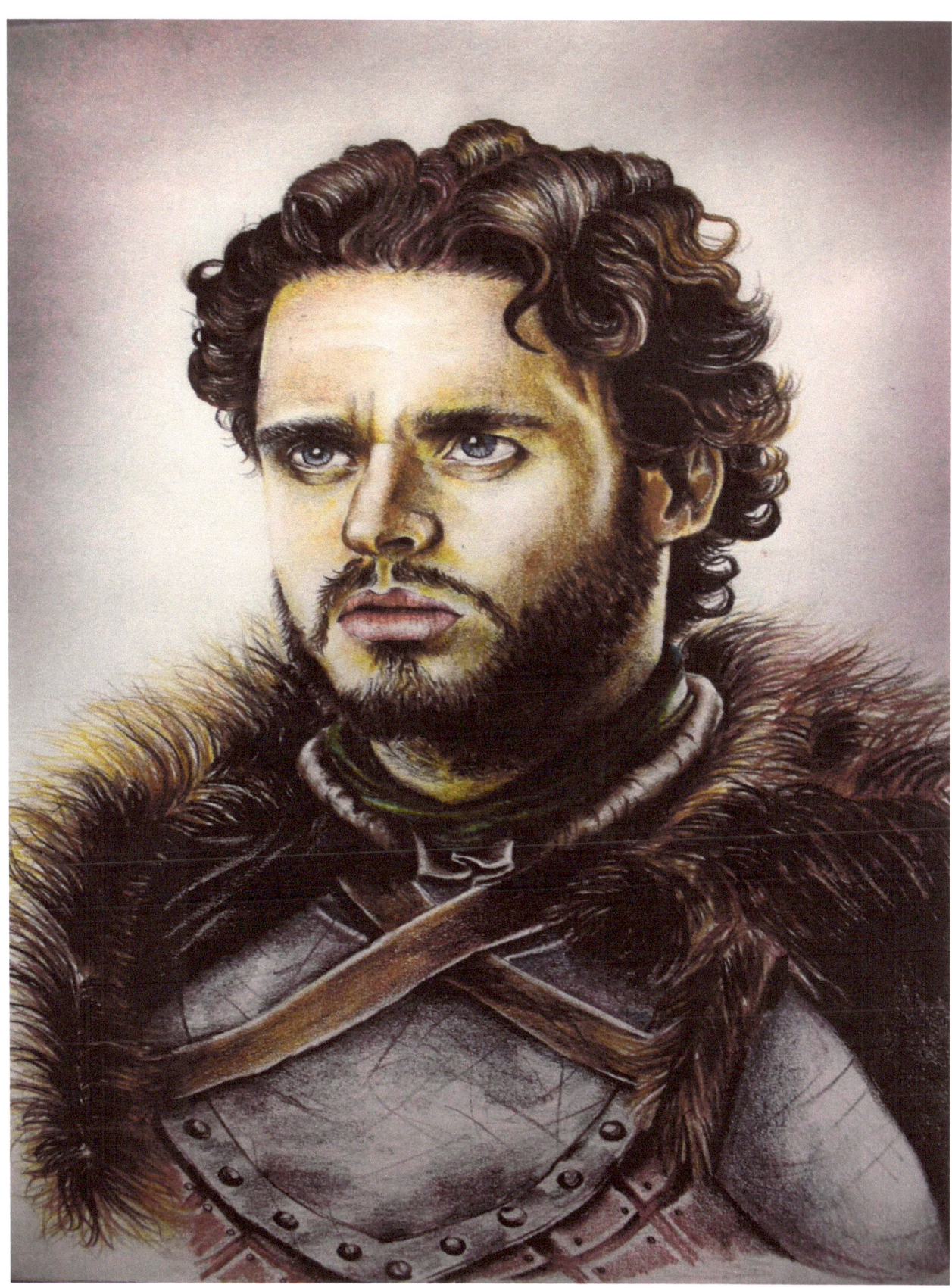

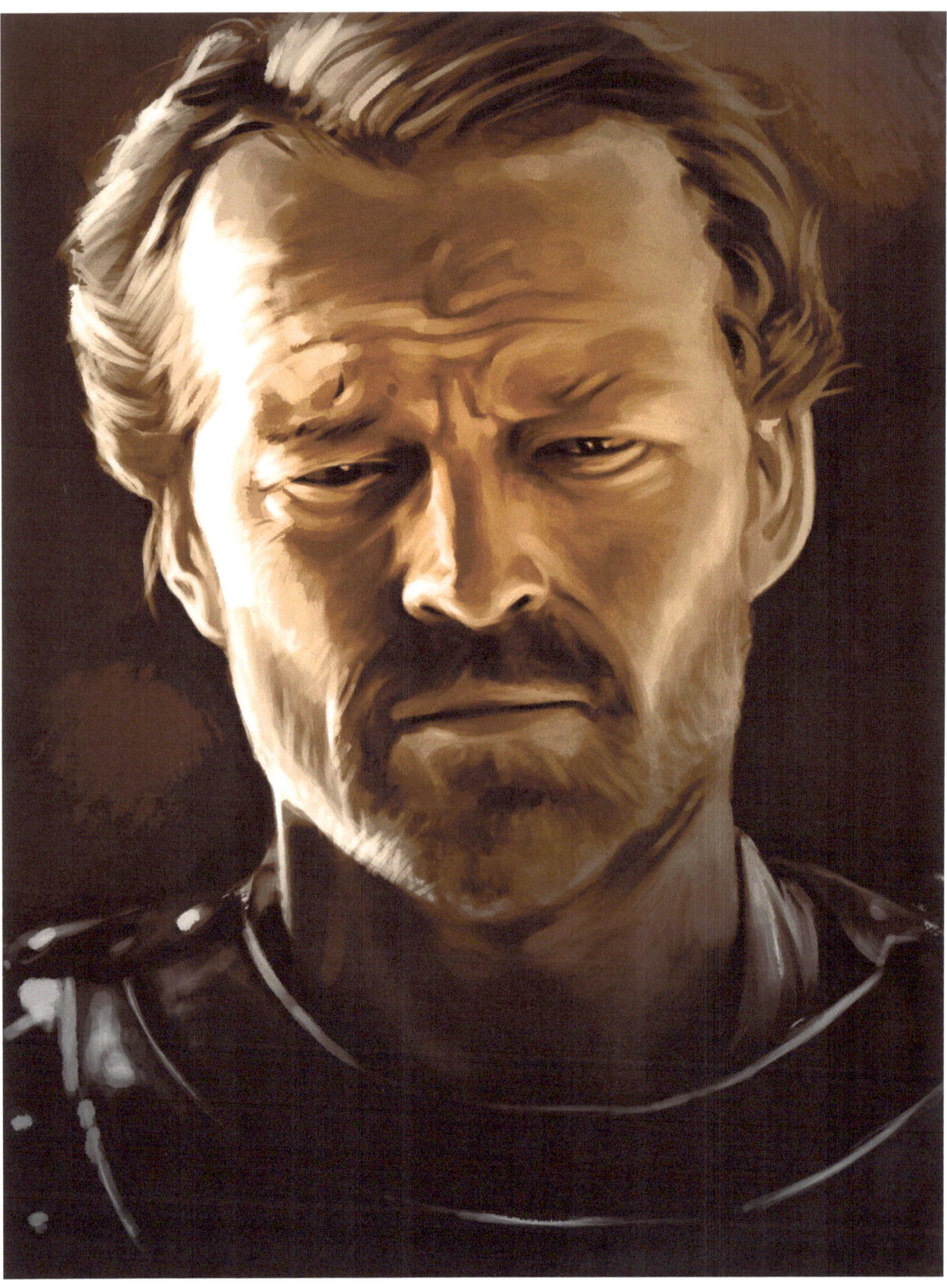

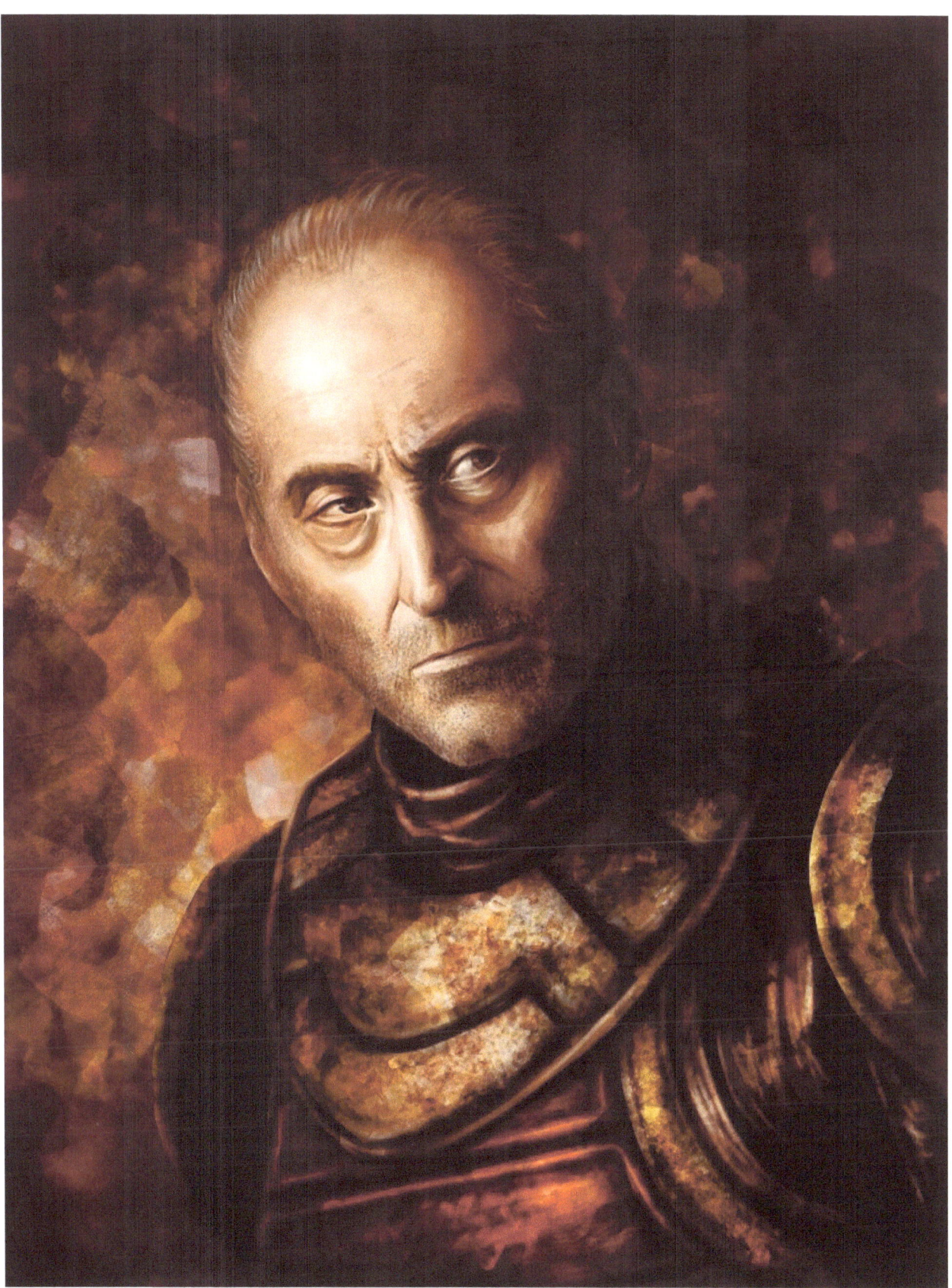

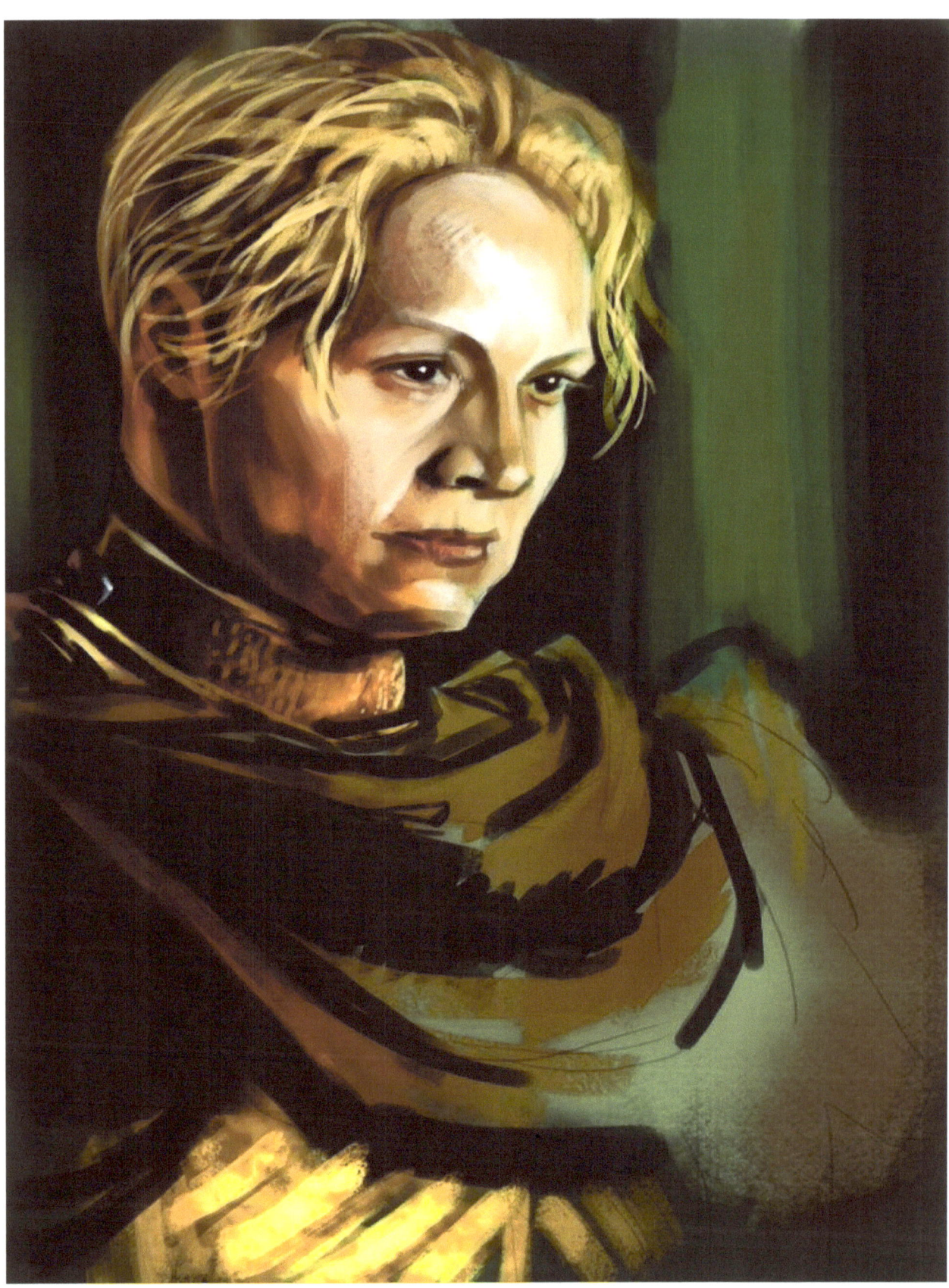

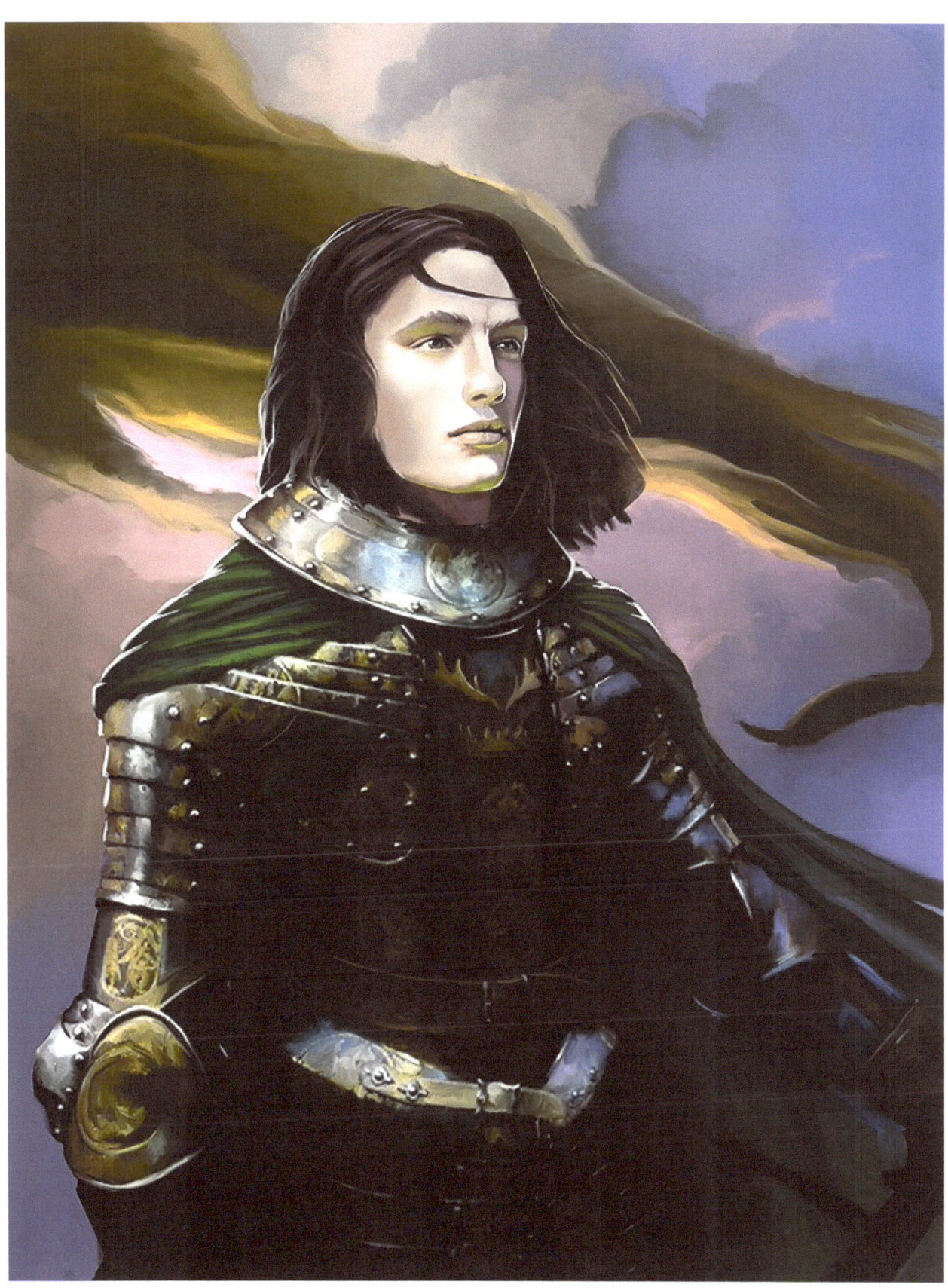

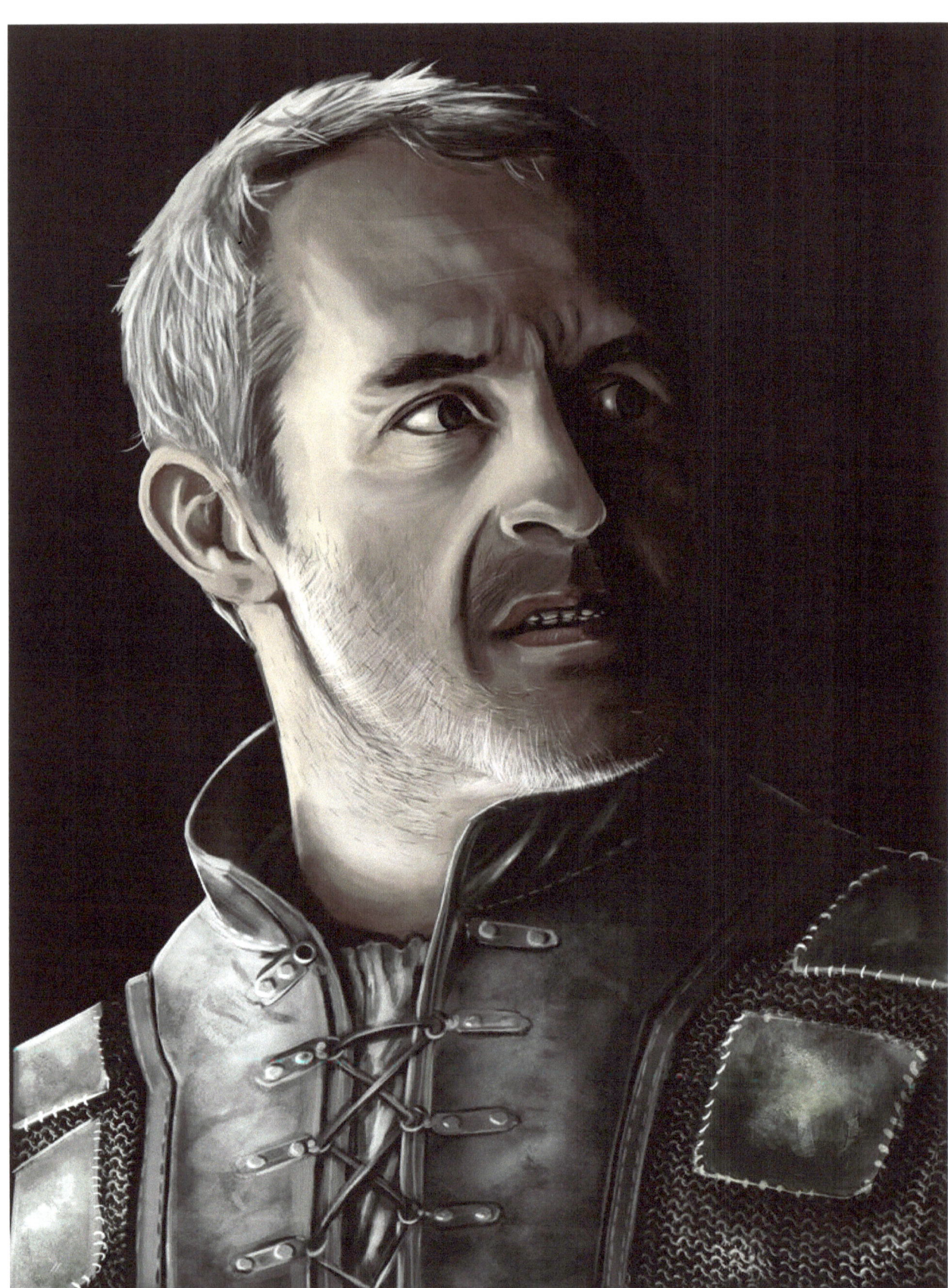

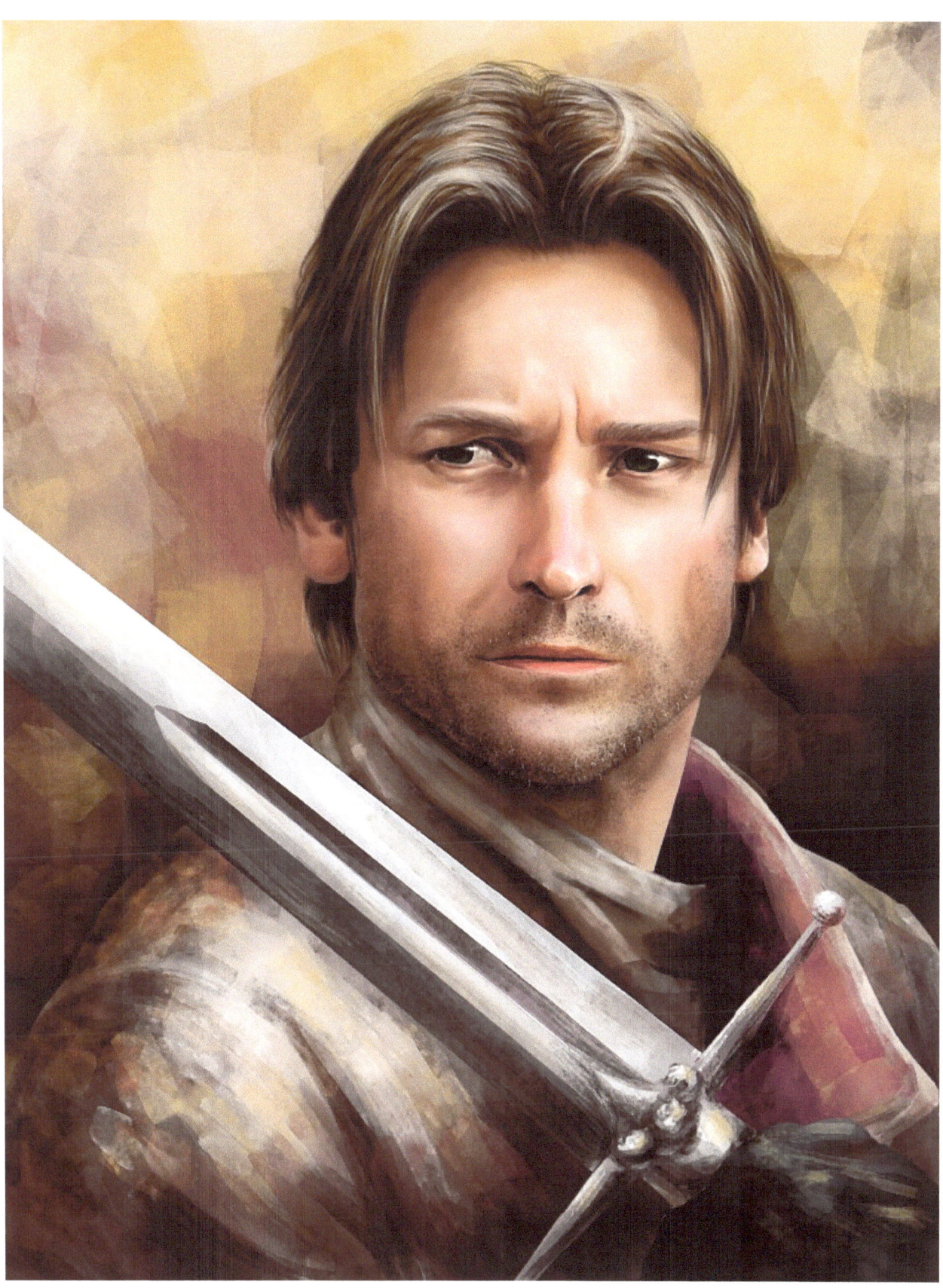

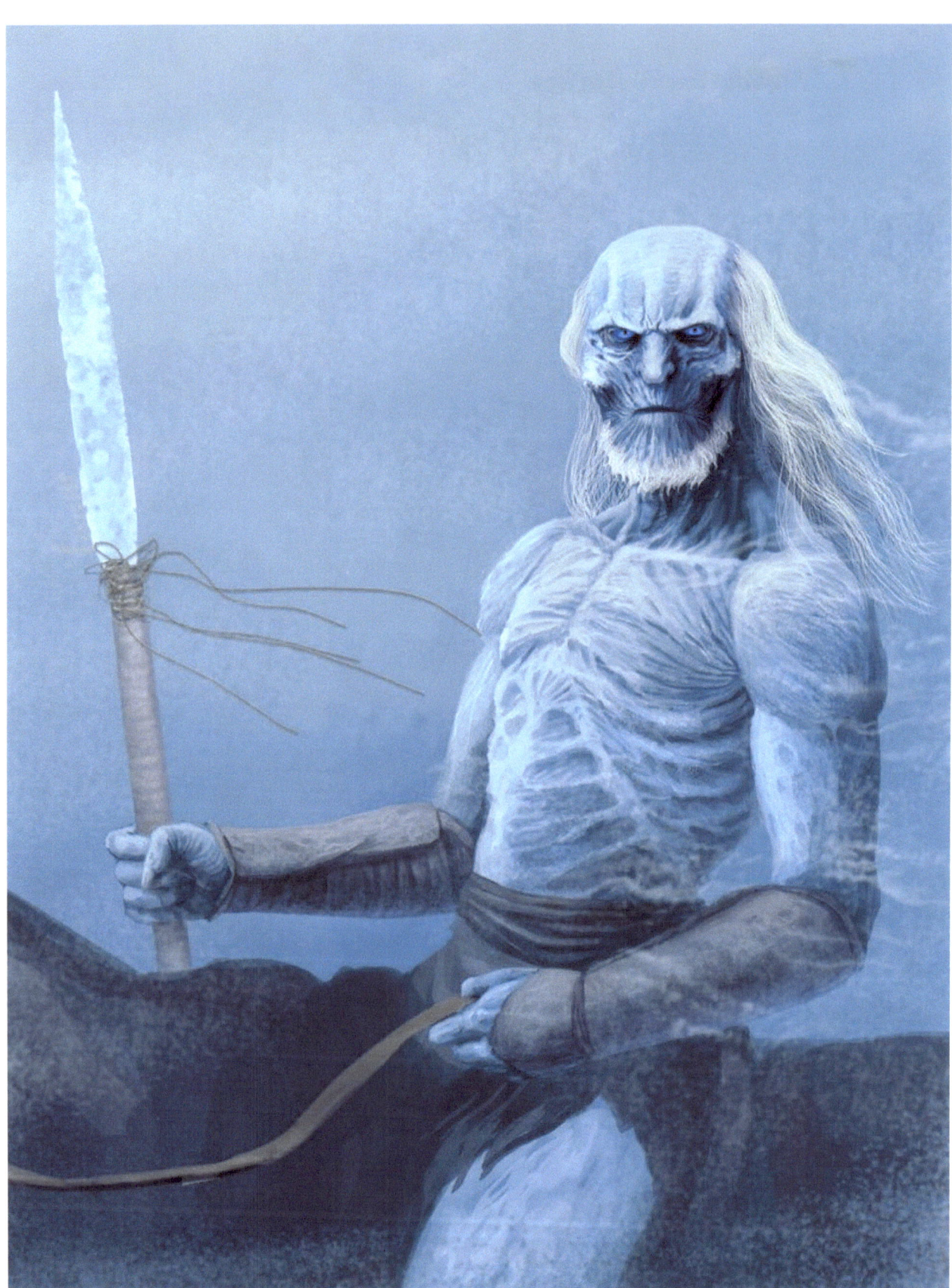

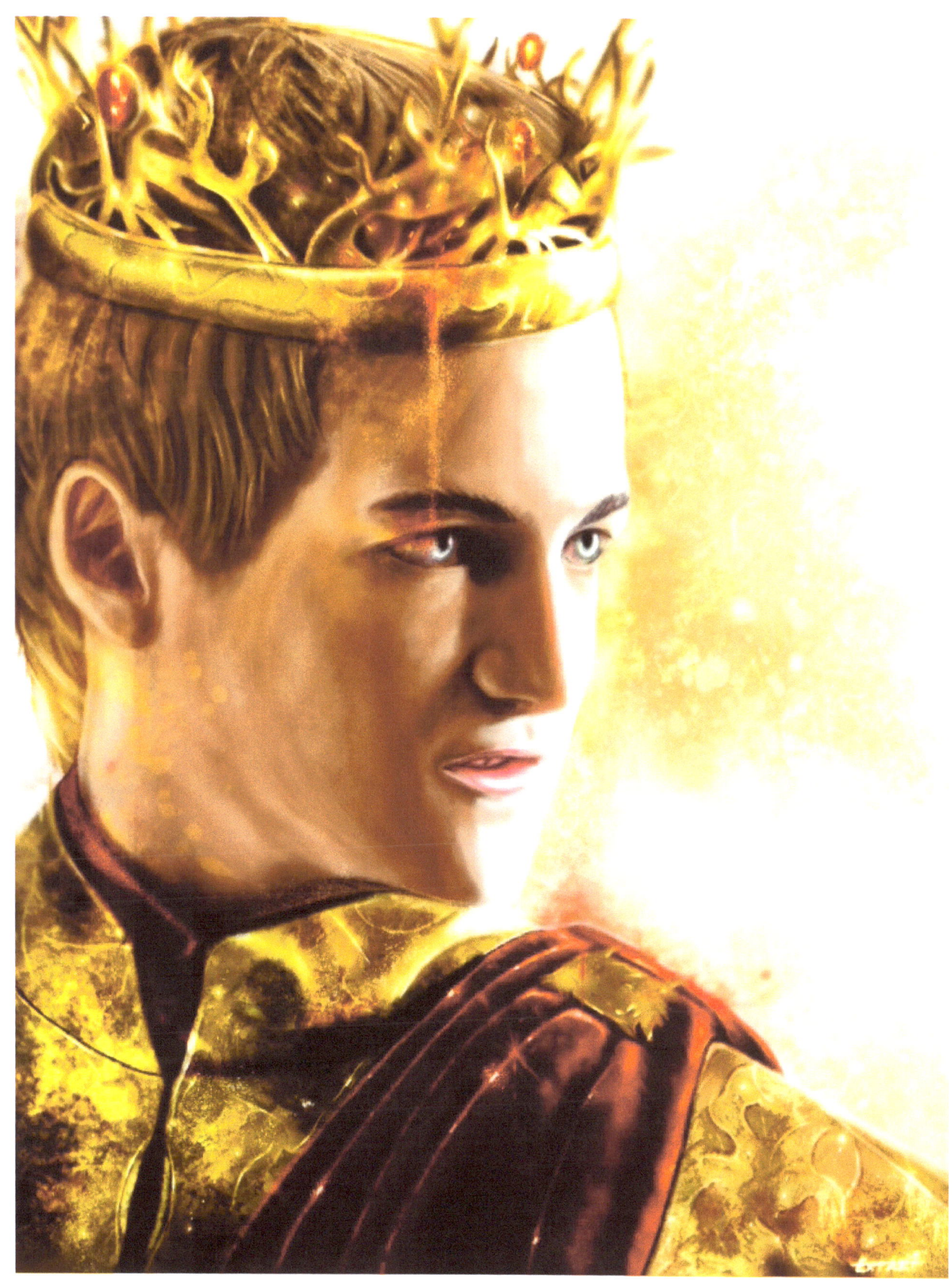

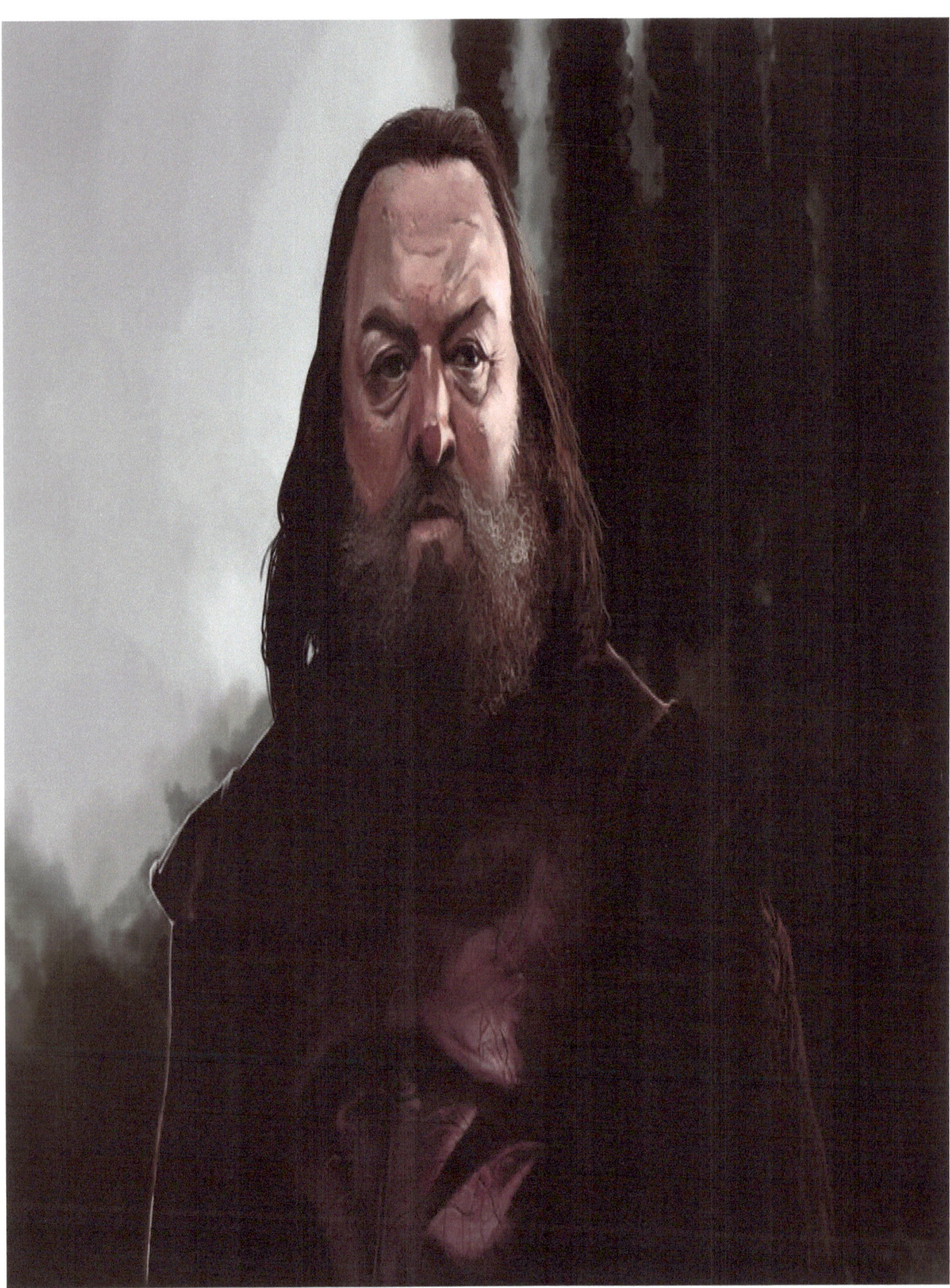

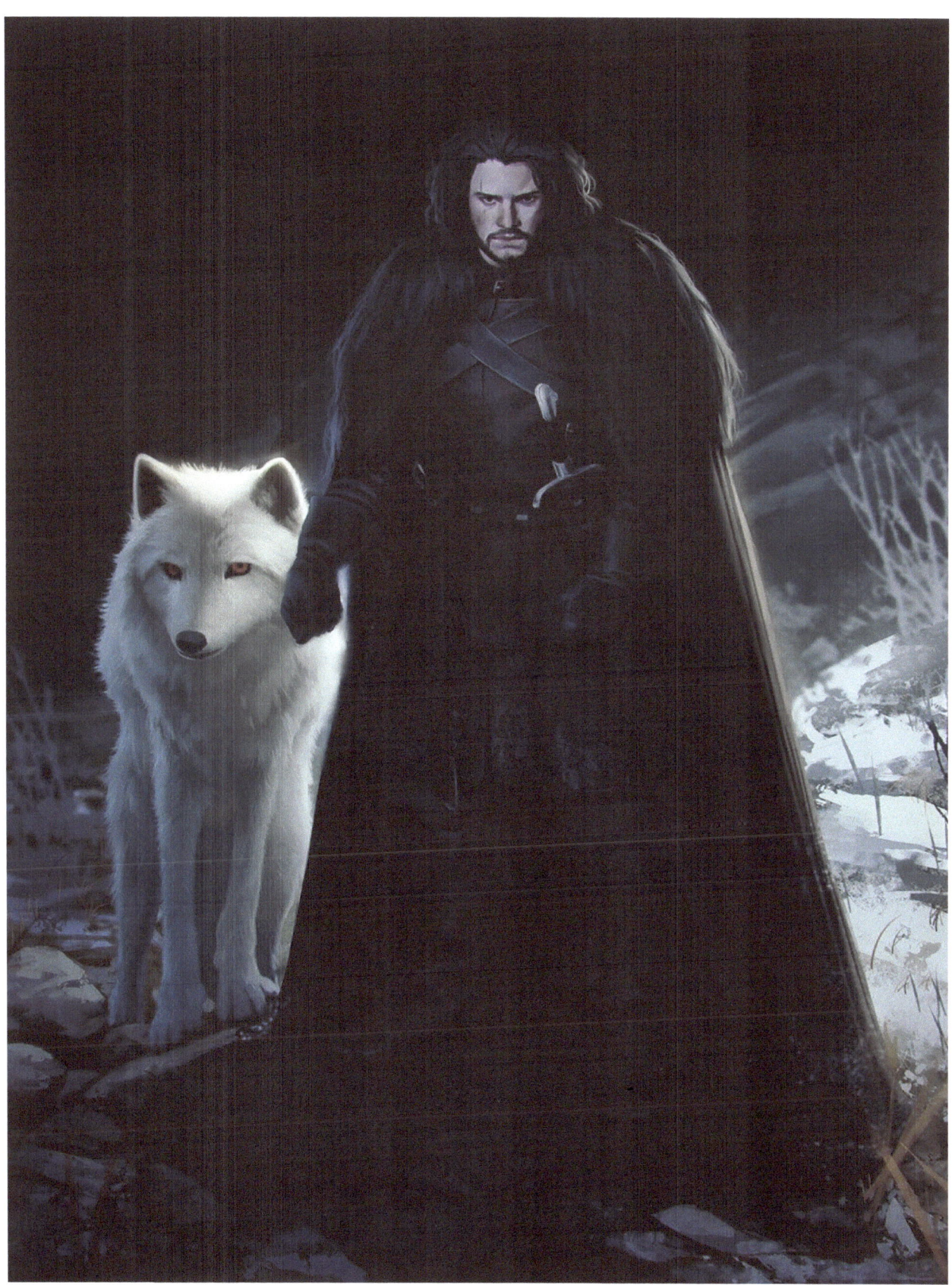

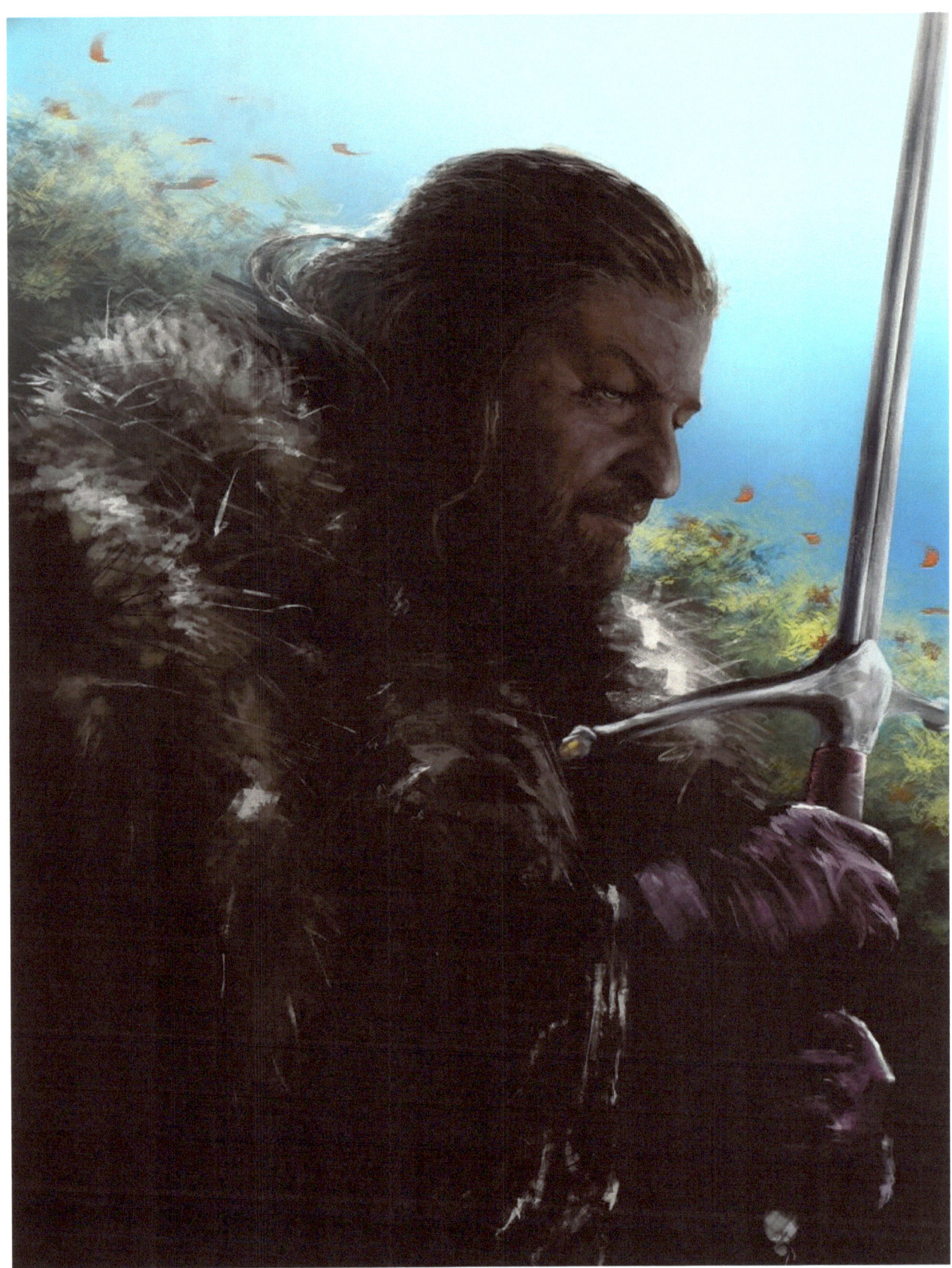

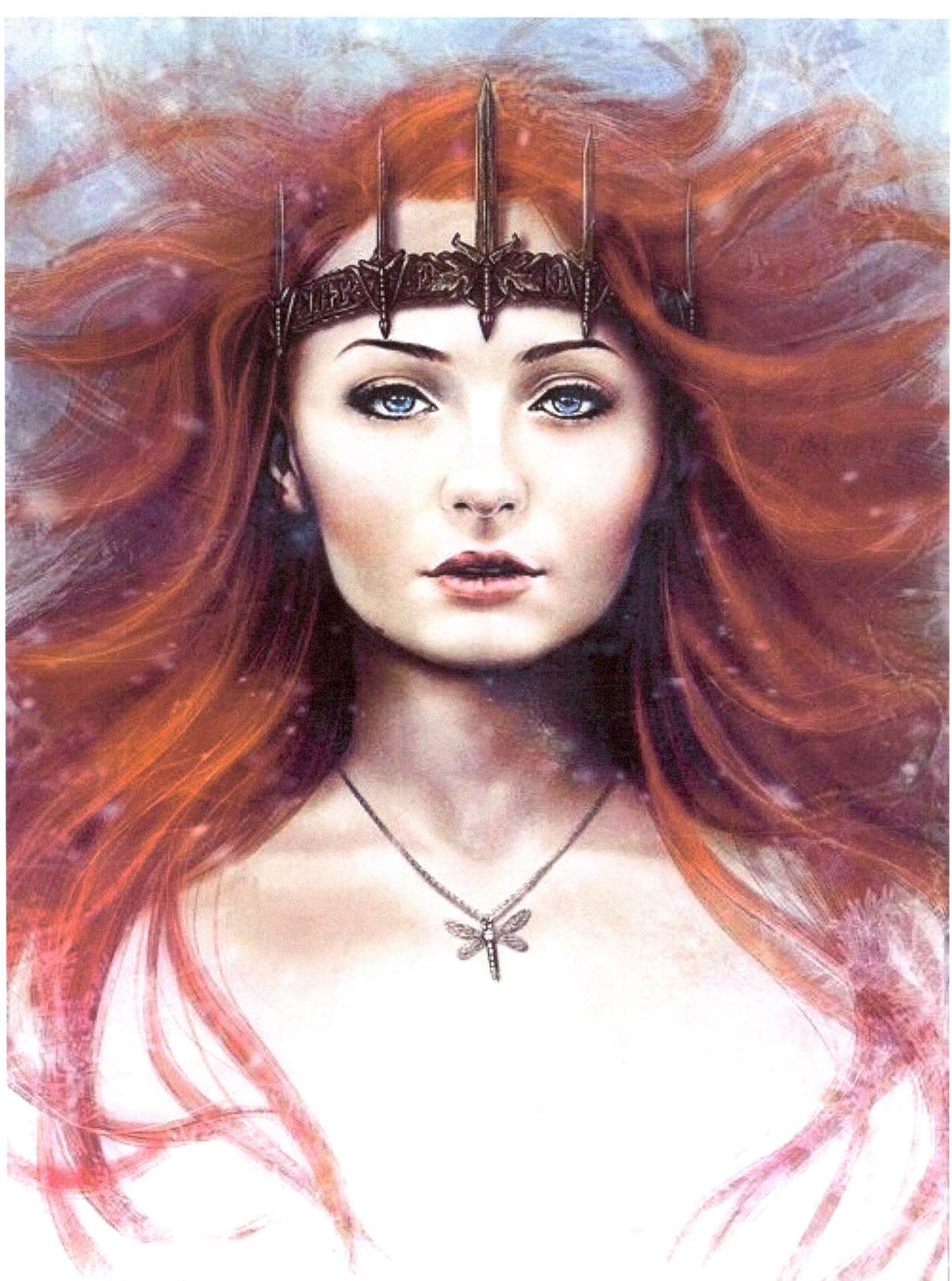

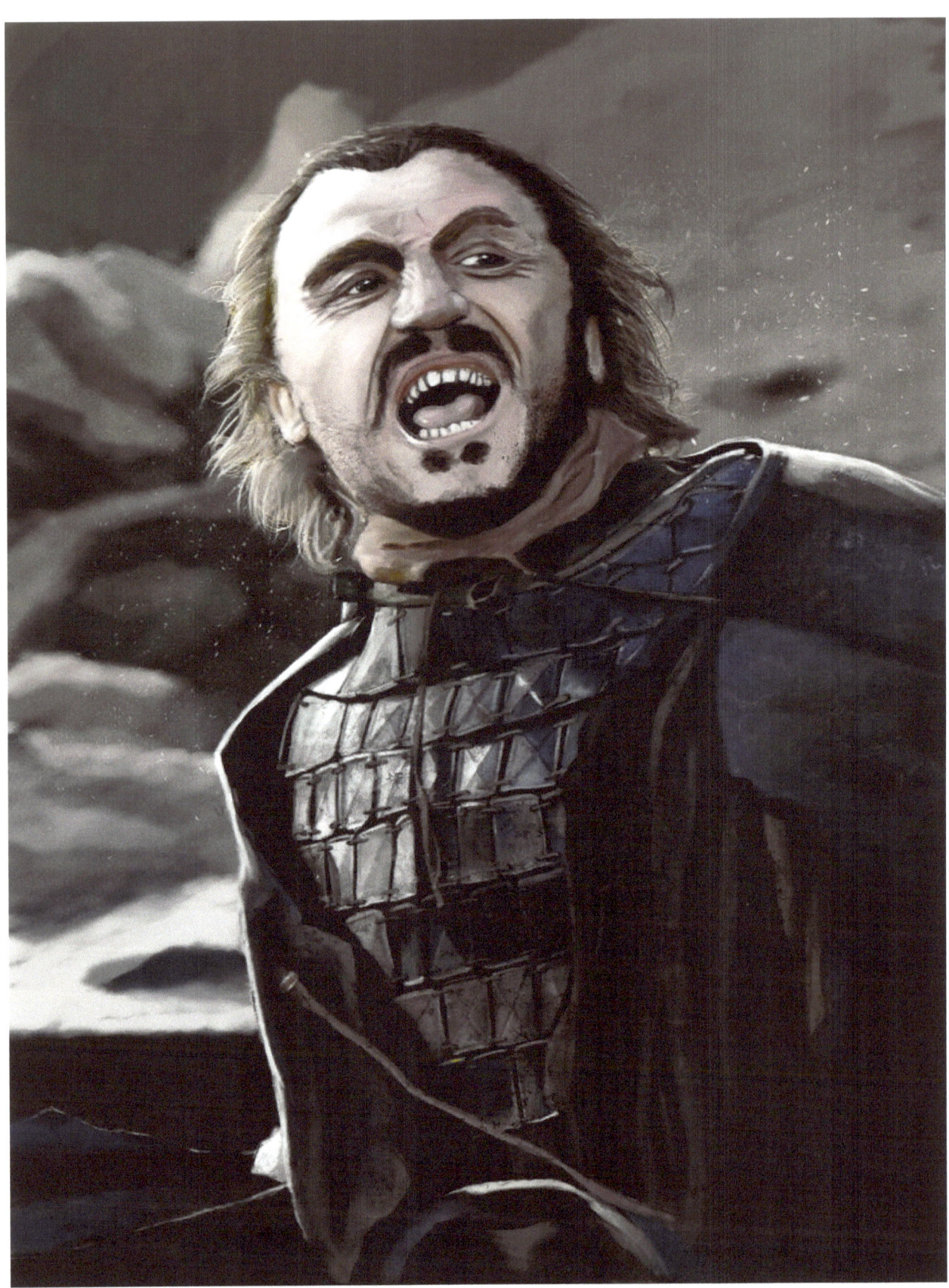